Pets

Sue Packer

dewi lewis publishing

For A. & B. Yung with love

First published in the UK in 2003 by
Dewi Lewis Publishing
8 Broomfield Road
Heaton Moor
Stockport SK4 4ND
+44 (0)161 442 9450

www.dewilewispublishing.com

ISBN: 1-904587-03-8

Design & artwork production: Dewi Lewis Publishing
Print: EBS, Verona

I had to have company – I was made for it, I think –
so I made friends with the animals. They are just
charming, and they have the kindest disposition and
the politest ways; they never look sour, they never let
you feel that you are intruding, they smile at you
and wag their tail, if they've got one, and they are
always ready for a romp or an excursion or
anything you want to propose.

Mark Twain – Eve's Diary

It is a matter to gain the affection of a cat.
He is a philosophical animal, tenacious of
his own habits, fond of order and neatness,
and disinclined to extravagant sentiment. He
will be your friend, if he finds you worthy of
friendship, but not your slave.

Theophile Gautier

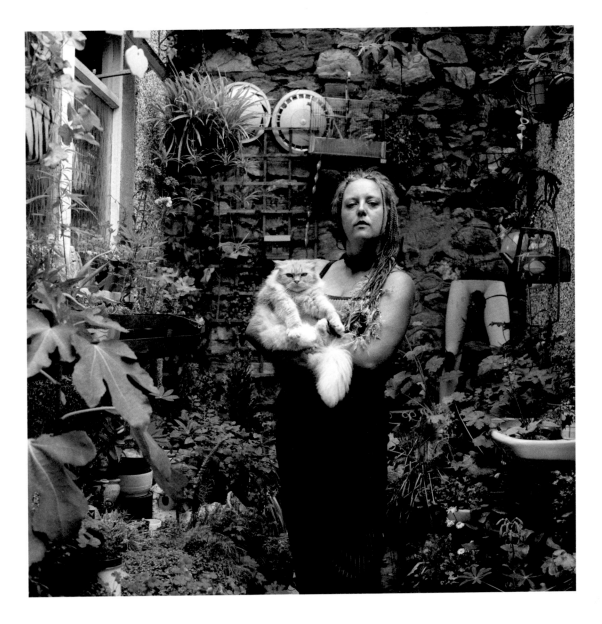

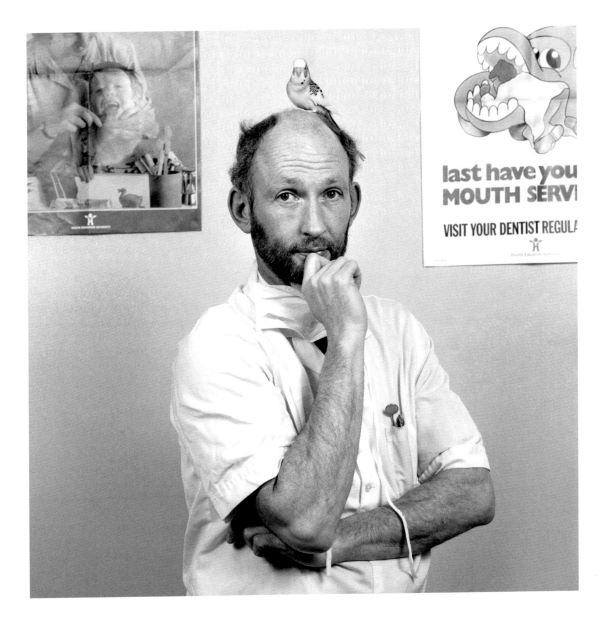

A dog has the soul of a philosopher.

Plato

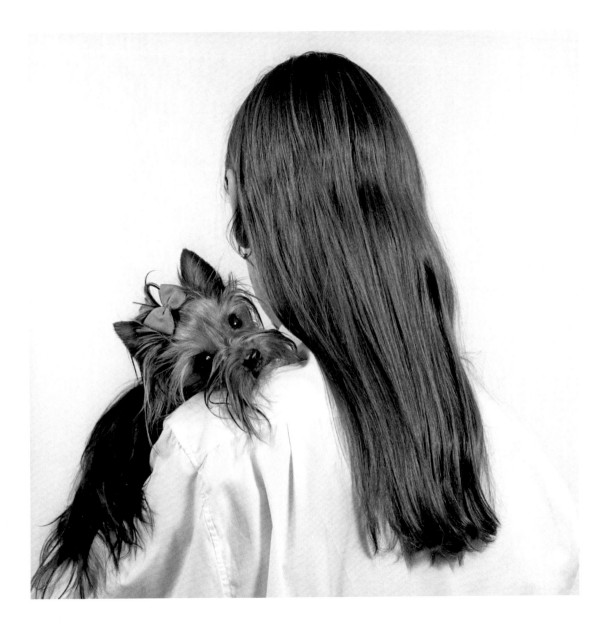

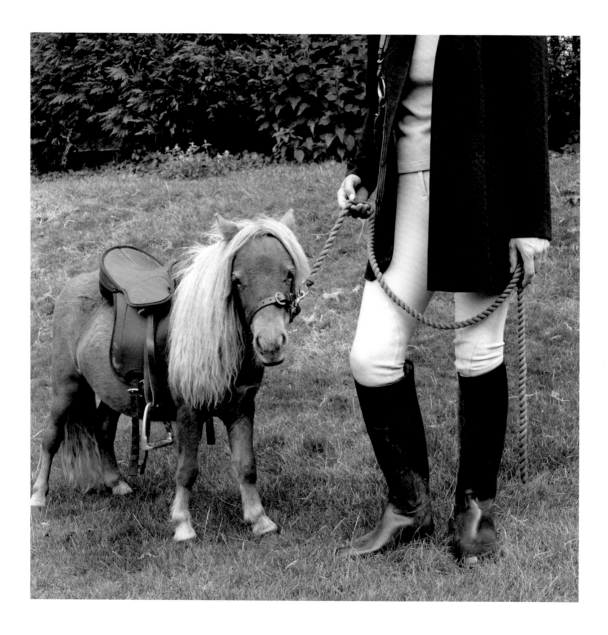

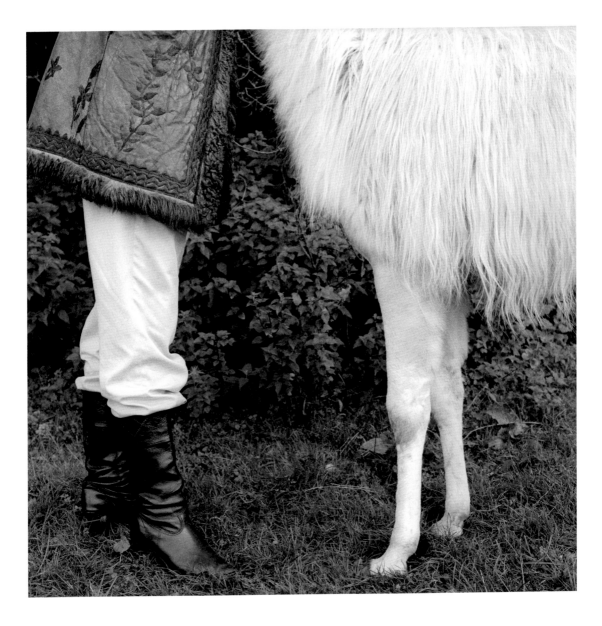

We call them dumb animals, and so they are,
for they cannot tell us how they feel, but they do
not suffer less because they have no words.

Anna Sewell, Black Beauty

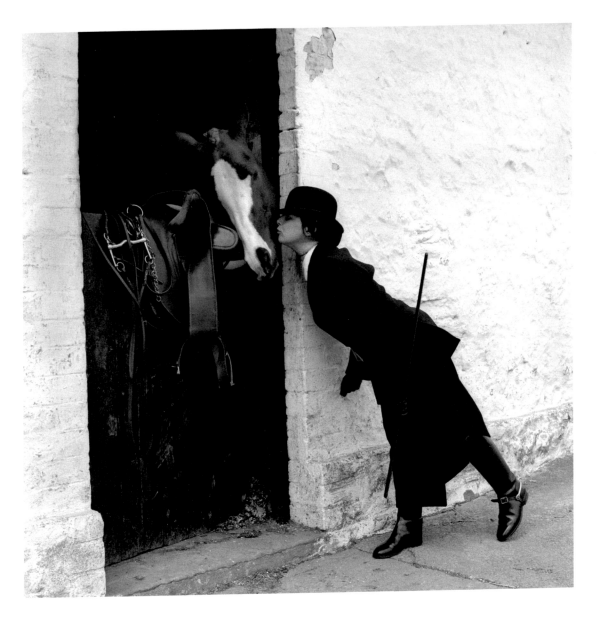

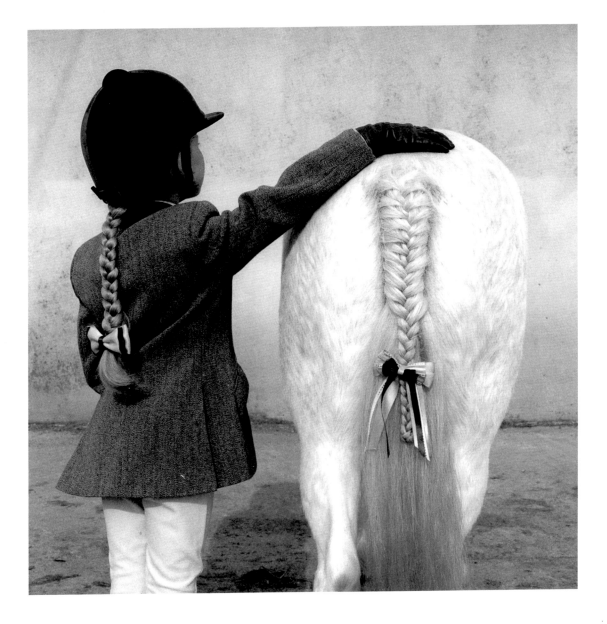

I am not an expert in horses
and do not speak with assurance.
I can always tell which is the front end
of a horse, but beyond that my art
is not above the ordinary.

Mark Twain

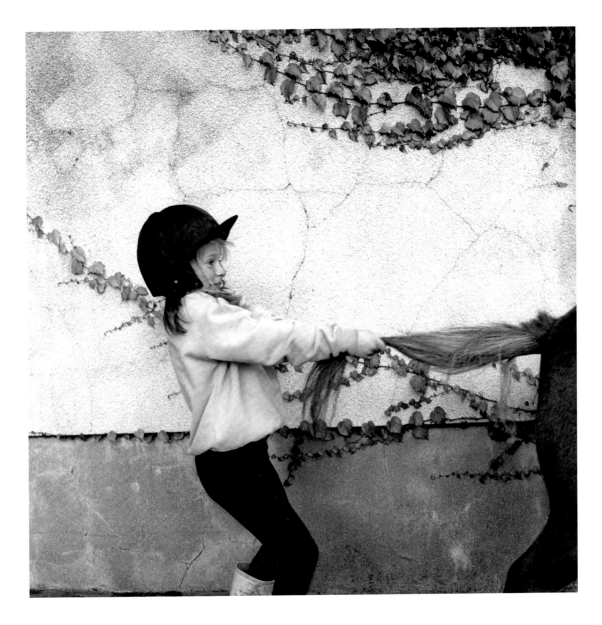

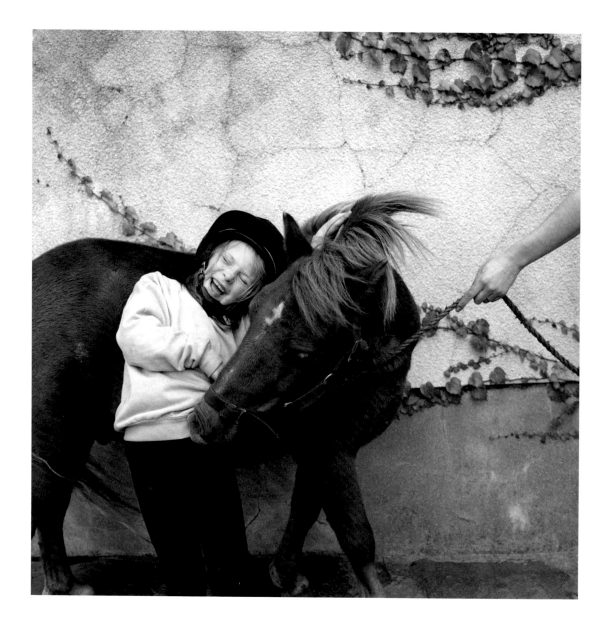

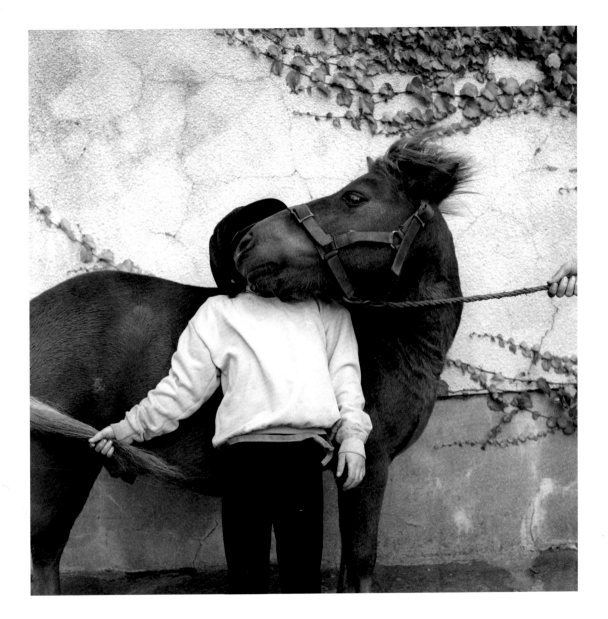

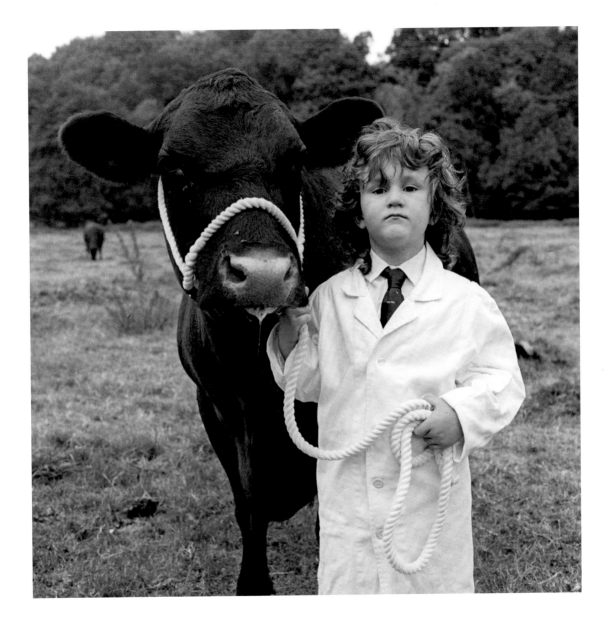

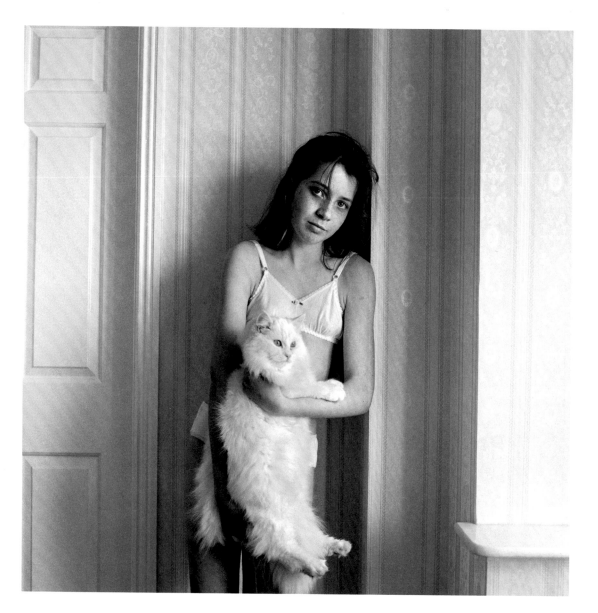

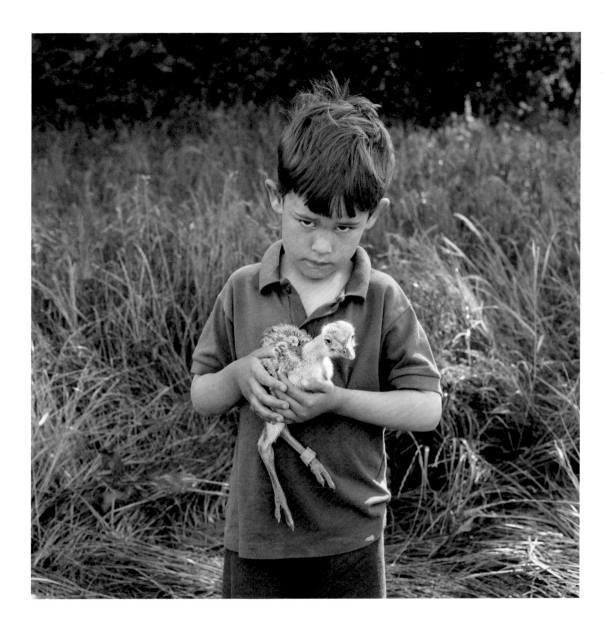

I believe cats to be spirits come to earth.
A cat, I am sure, could walk on a cloud
without coming through.

Jules Verne

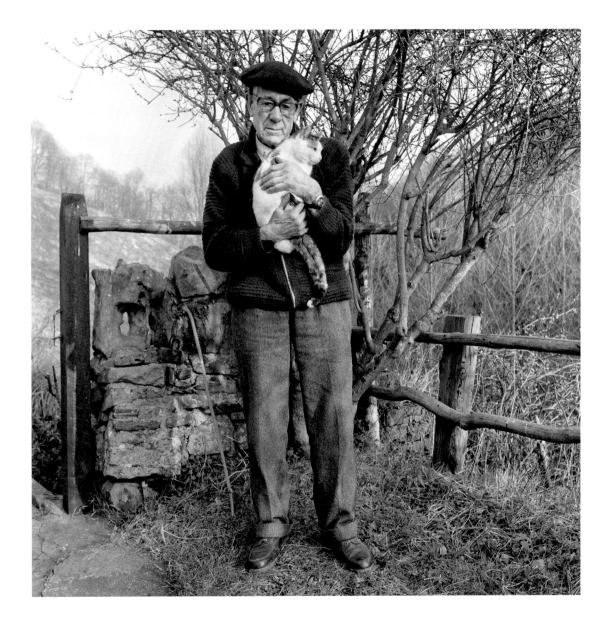

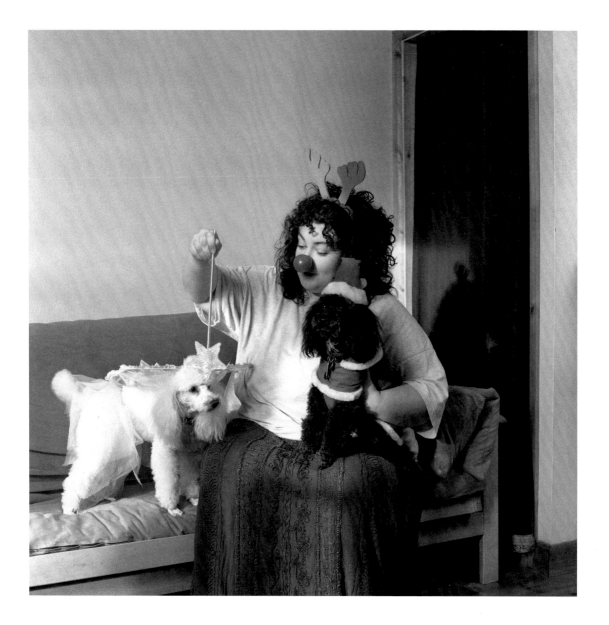

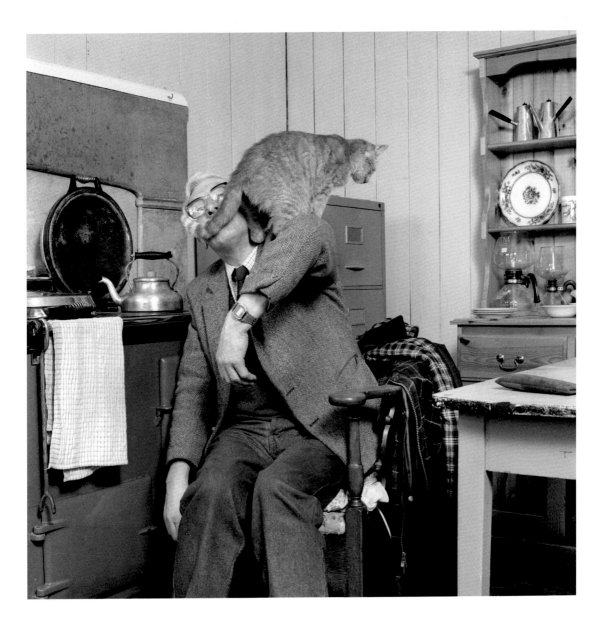

The world was conquered through the understanding of dogs;
the world exists through the understanding of dogs.

Nietzche

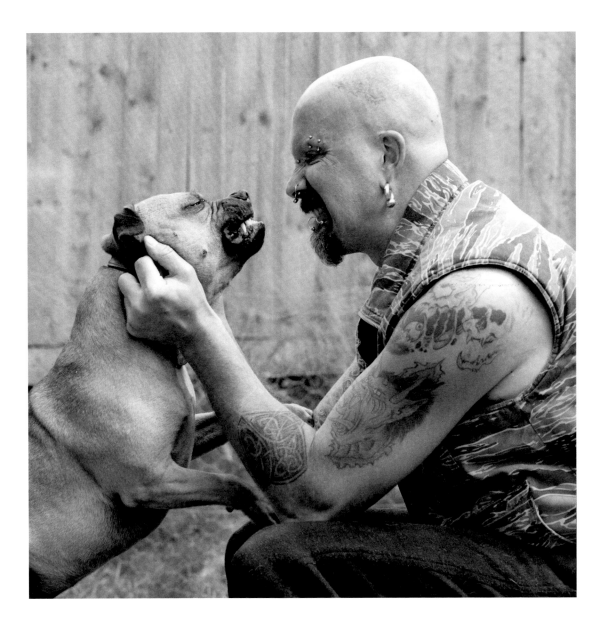

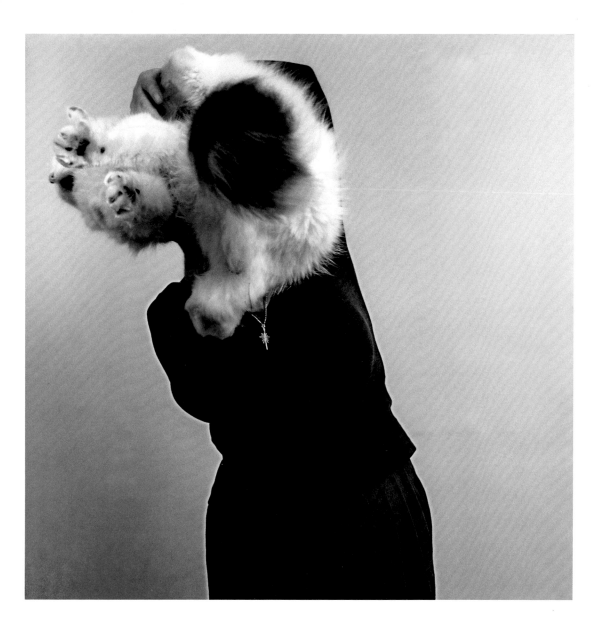

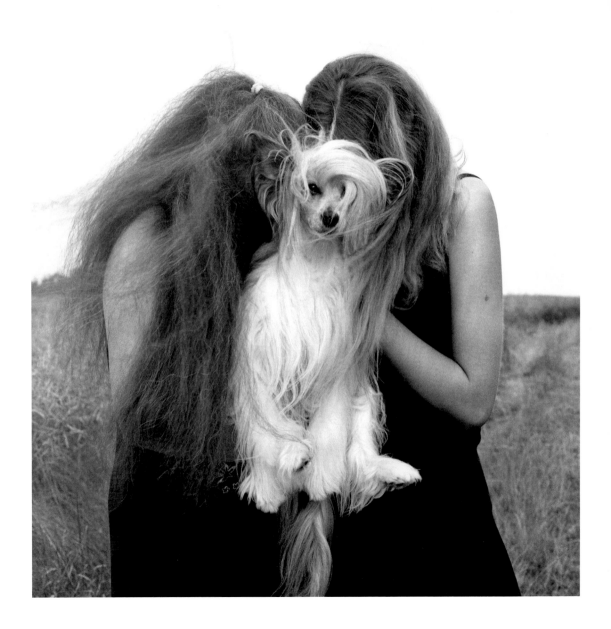

Don't approach a goat from the front,
a horse from the back, or a fool from any side.

Proverb

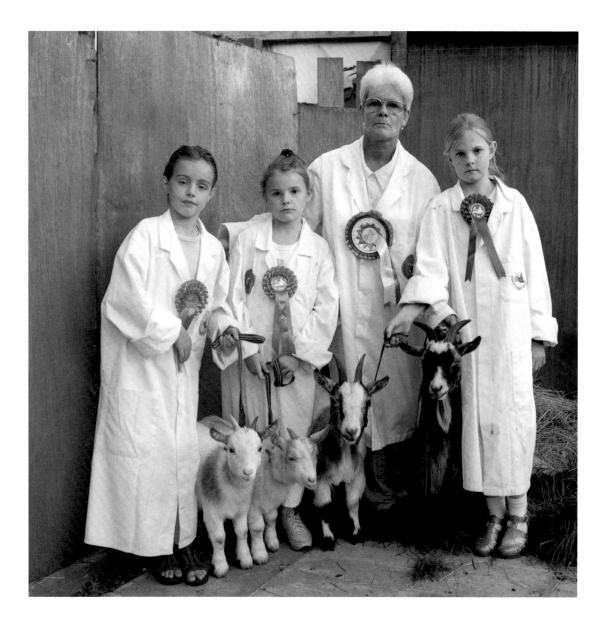

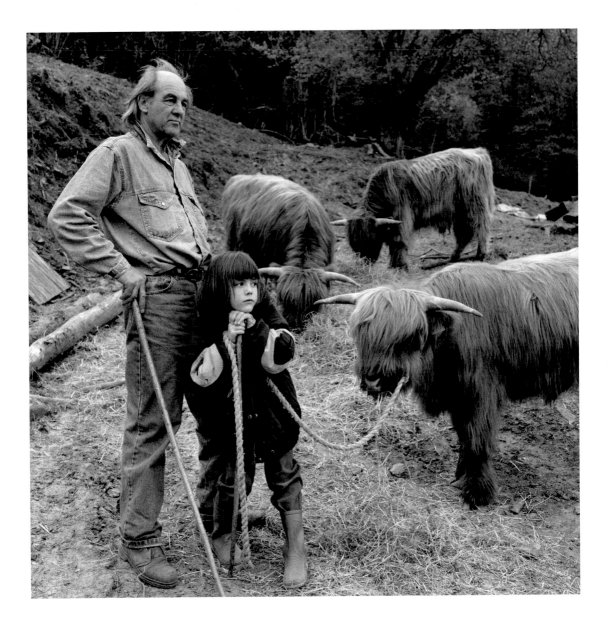

Dogs believe they are human.
Cats believe they are God.

Unknown

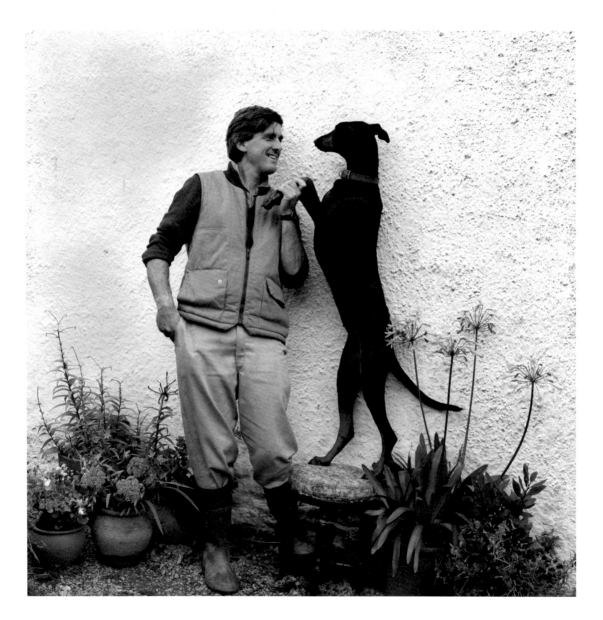

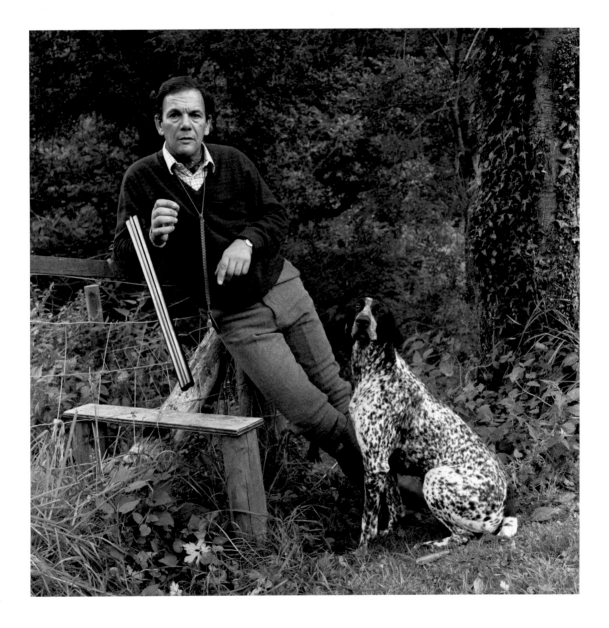

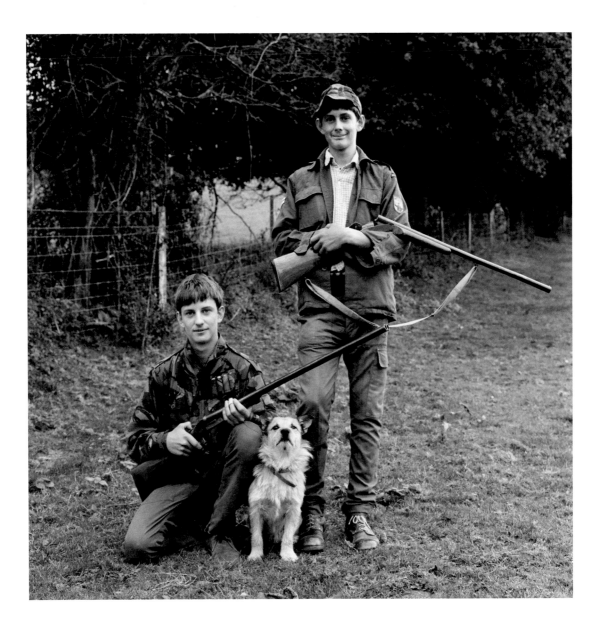

When the eagles are silent,
the parrots begin to jabber.

Sir Winston Churchill

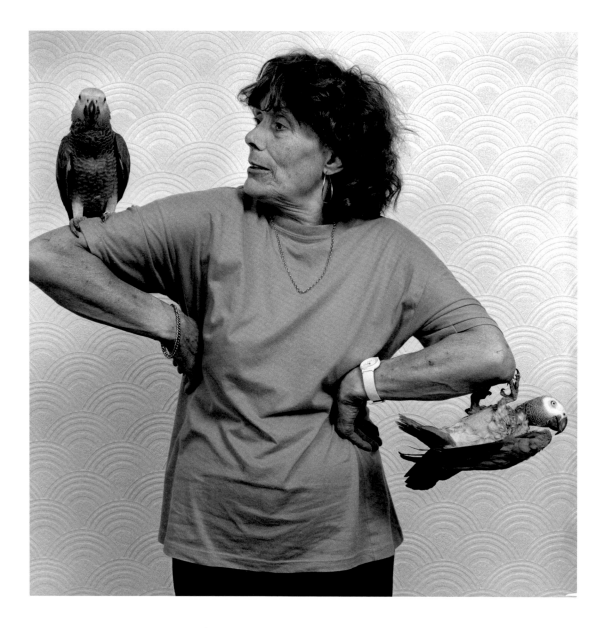

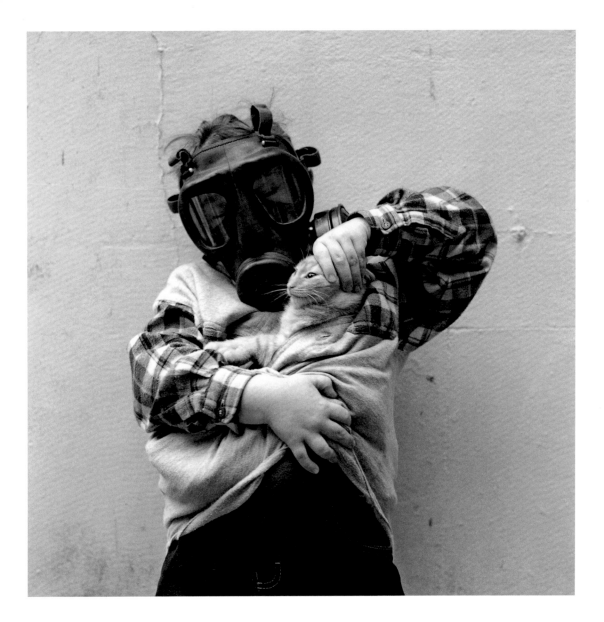

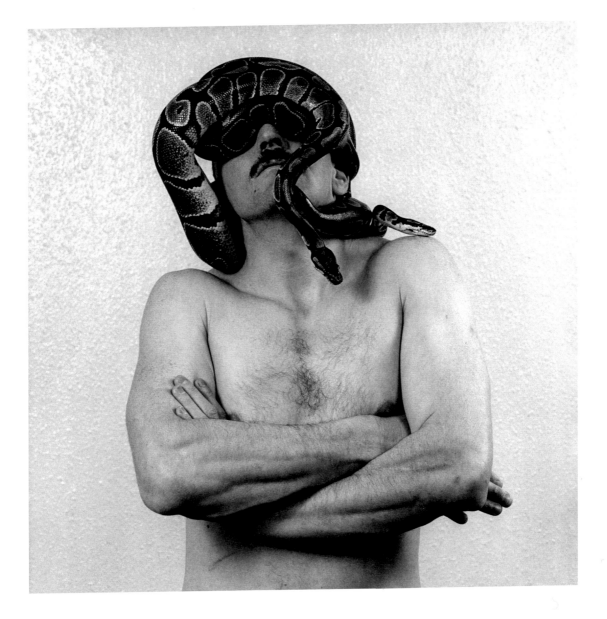

The spider's touch, how exquisitely fine!
Feels at each thread, and lives along the line

Alexander Pope

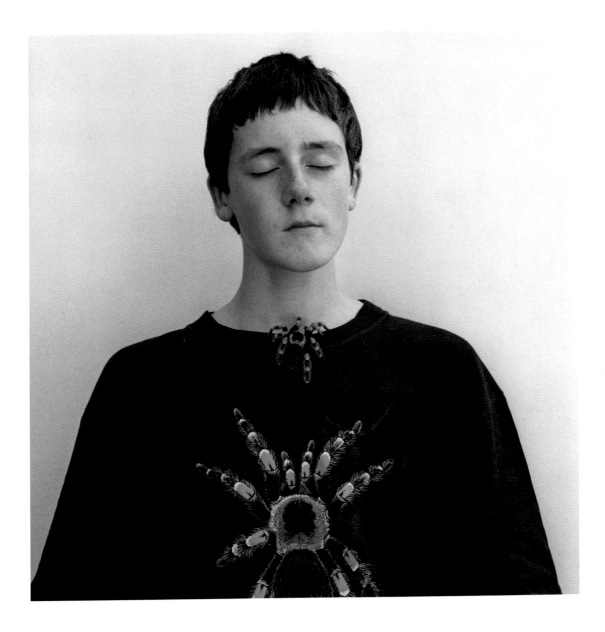

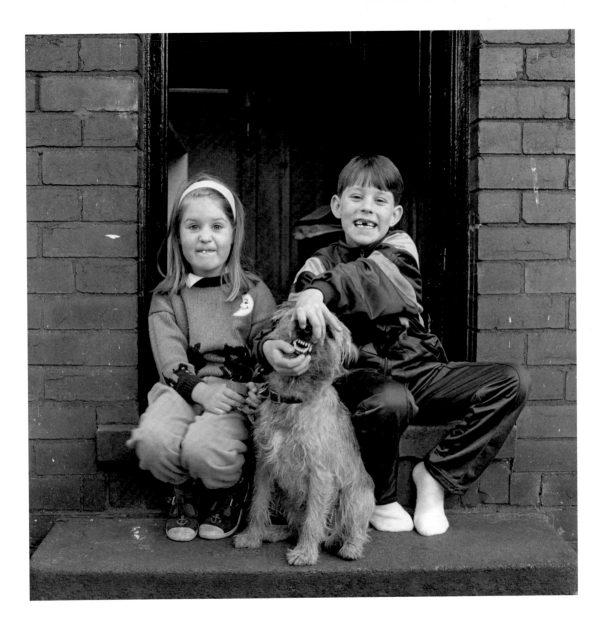

If you eliminate smoking and gambling, you will be
amazed to find that almost all an Englishman's pleasures
can be, and mostly are, shared by his dog.

George Bernard Shaw

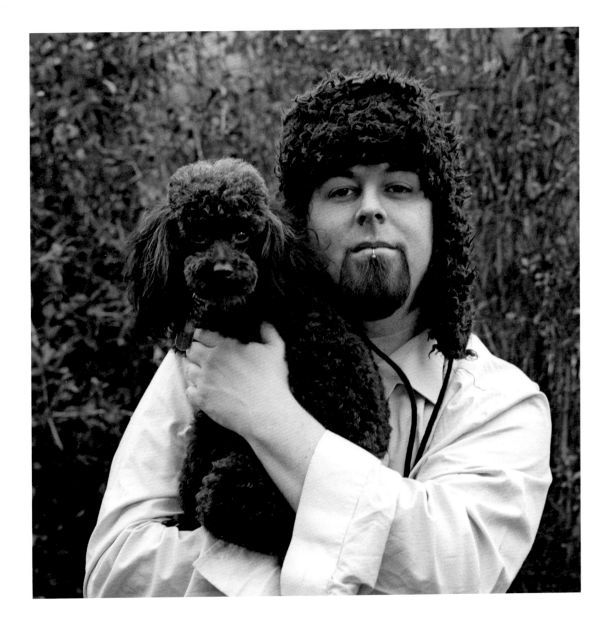

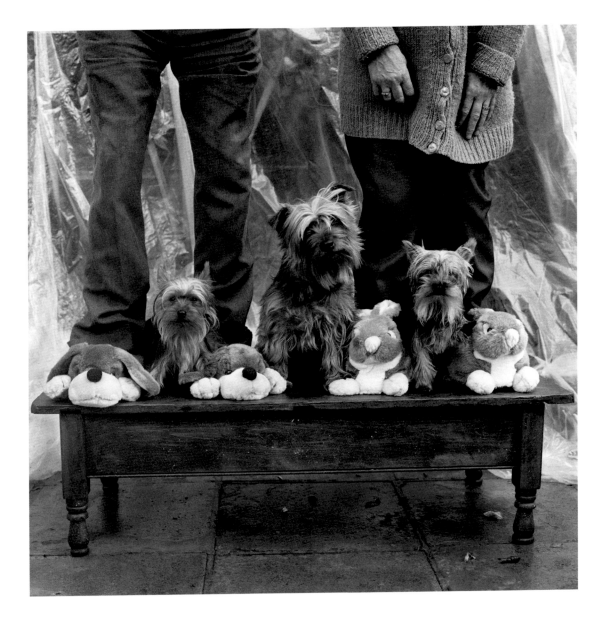

I would rather see the portrait of a dog
that I know, than all the allegorical paintings
they can show me in the world.

Samuel Johnson

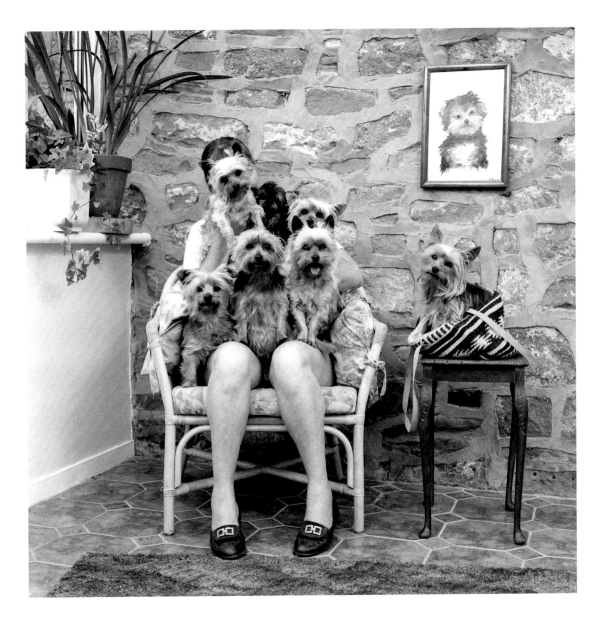

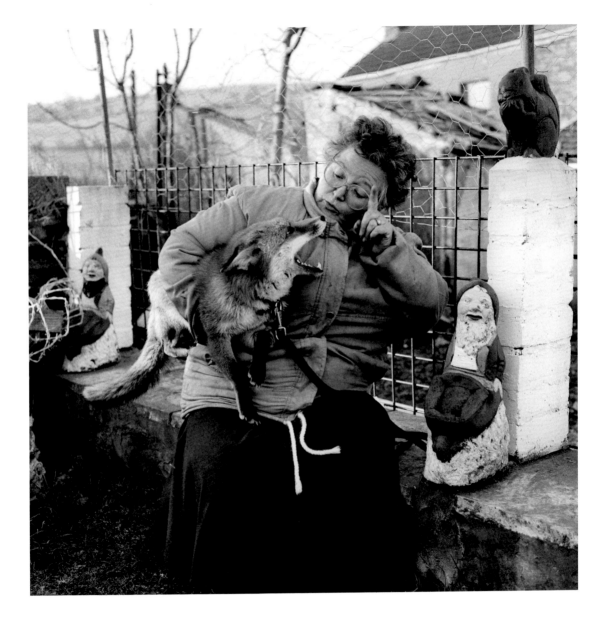

Our task must be to free ourselves from the prison by widening our circle of compassion to embrace all living creatures and the whole of nature in its beauty...

Albert Einstein

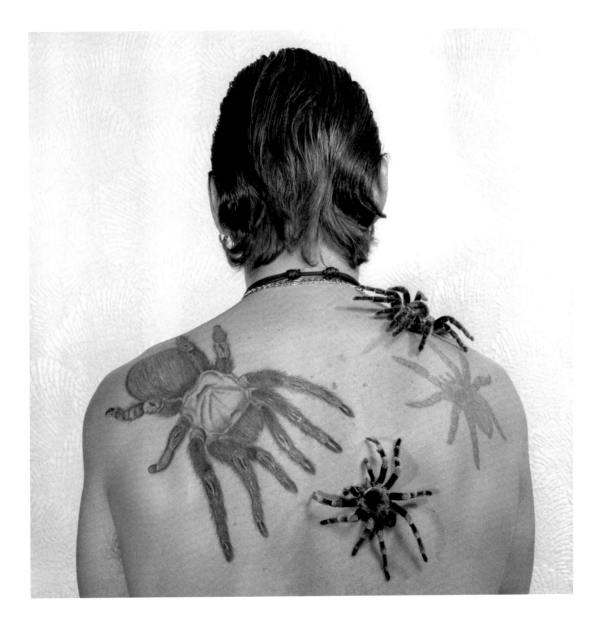

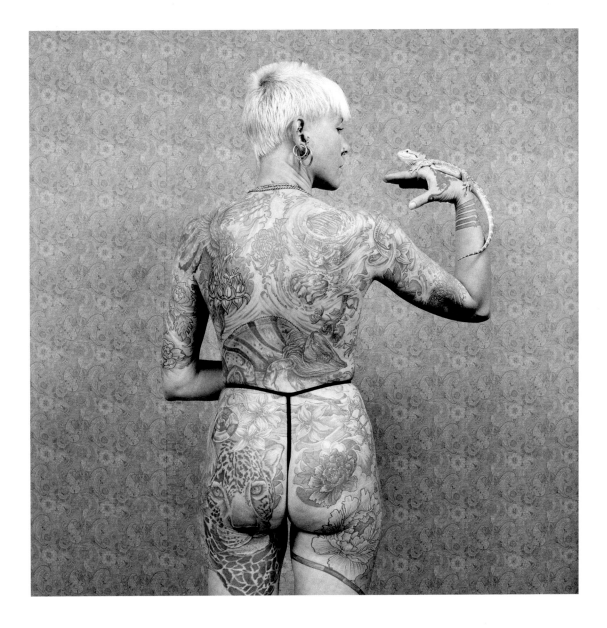

Until one has loved an animal,
a part of one's soul remains unawakened.

Anatole France

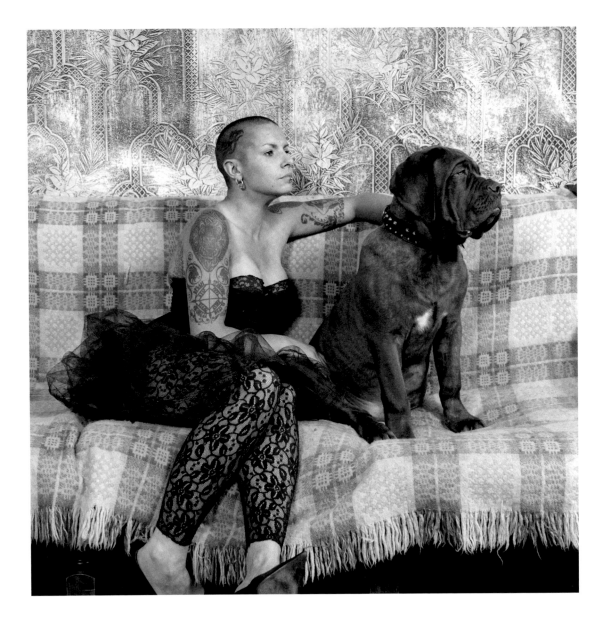

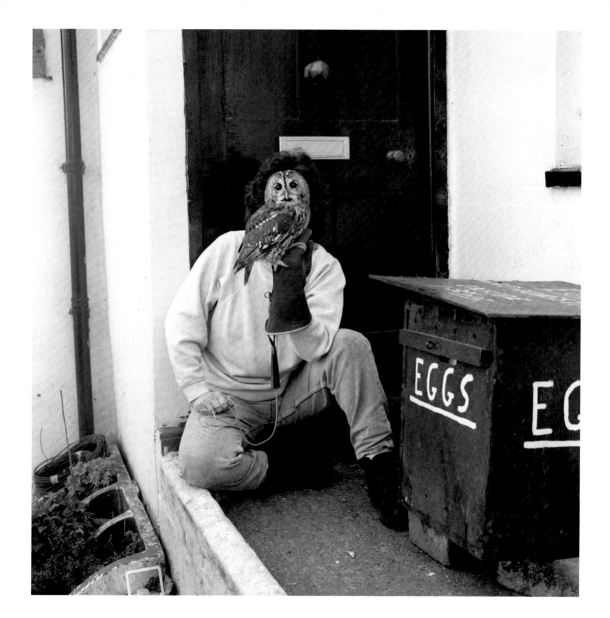

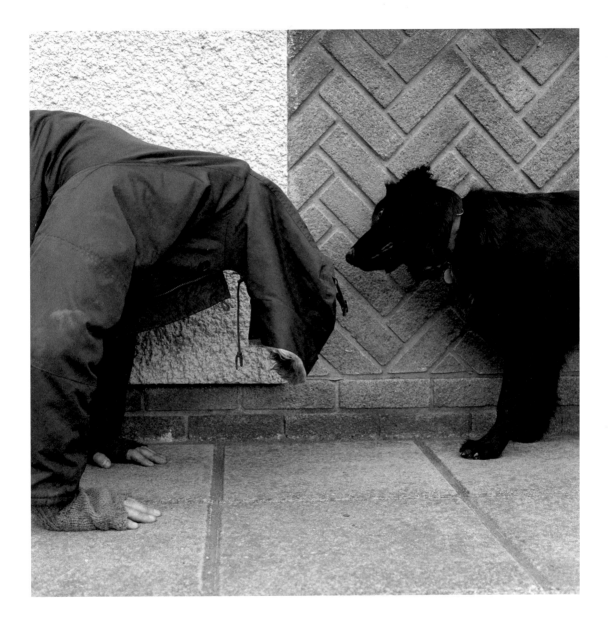

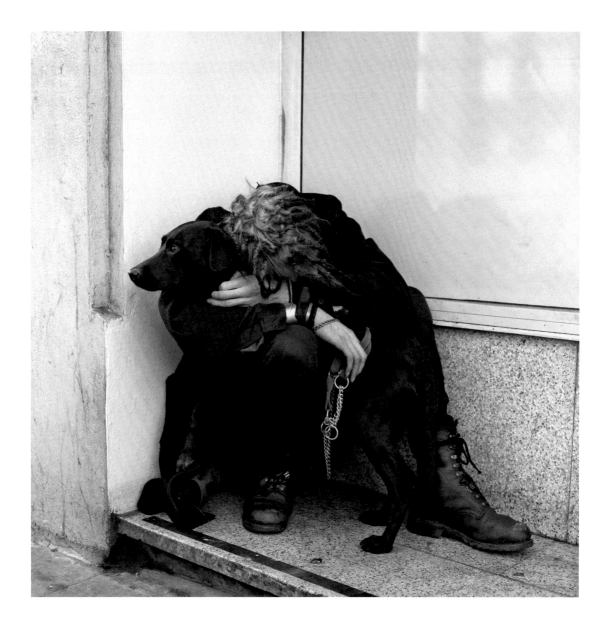

Histories are more full of examples
of the fidelity of dogs than of friends.

Alexander Pope

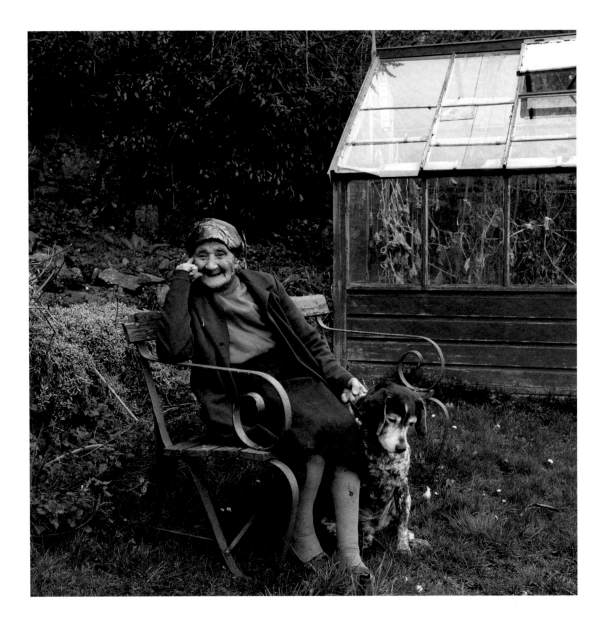

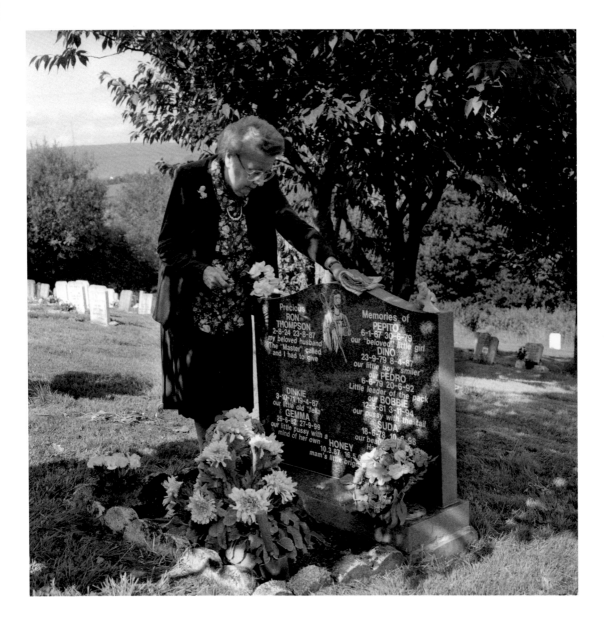

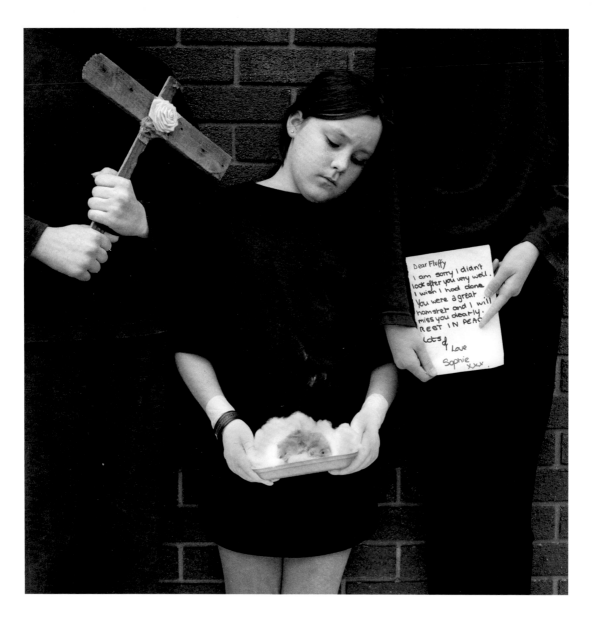

The behaviour of men to animals and their behaviour to
each other bear a constant relationship.

Herbert Spencer

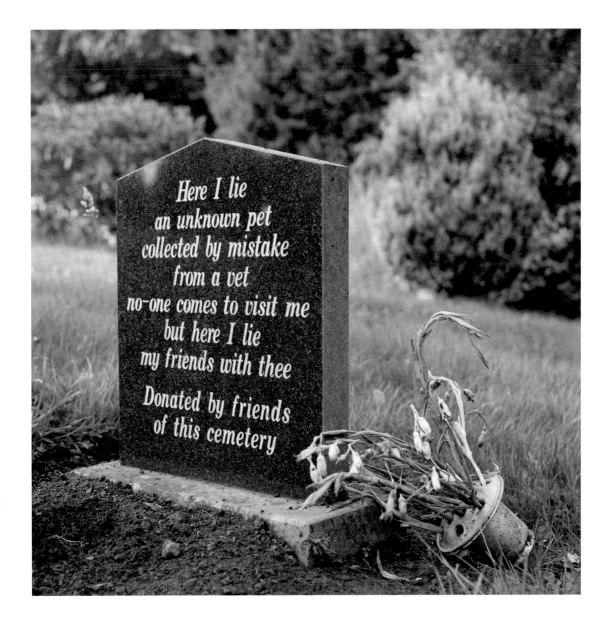

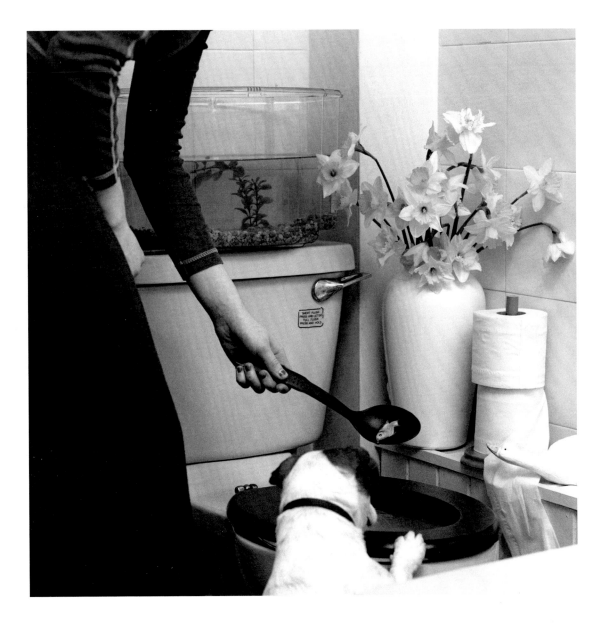

There are two things for which animals are
to be envied: they know nothing of future evils,
or of what people say about them.

Voltaire

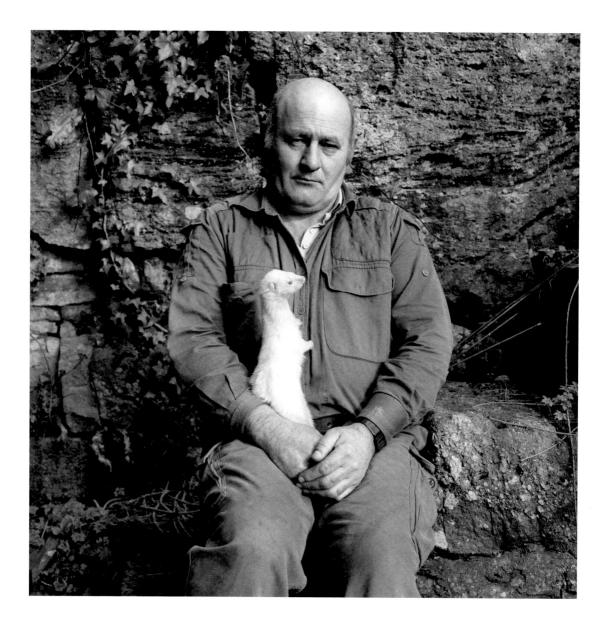

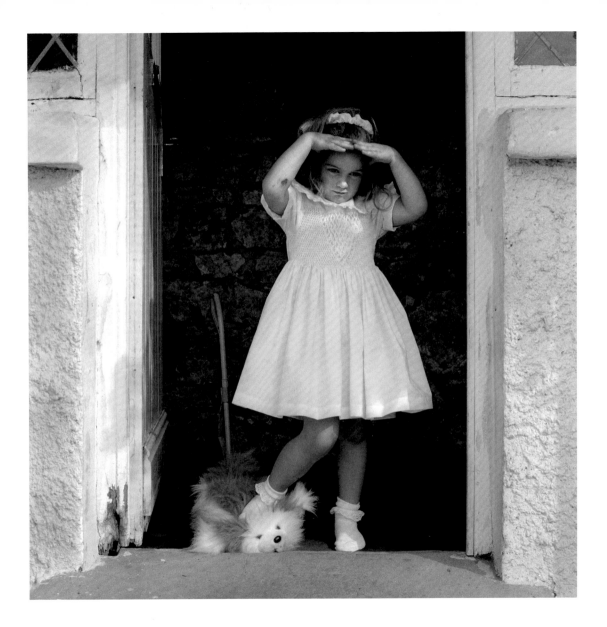

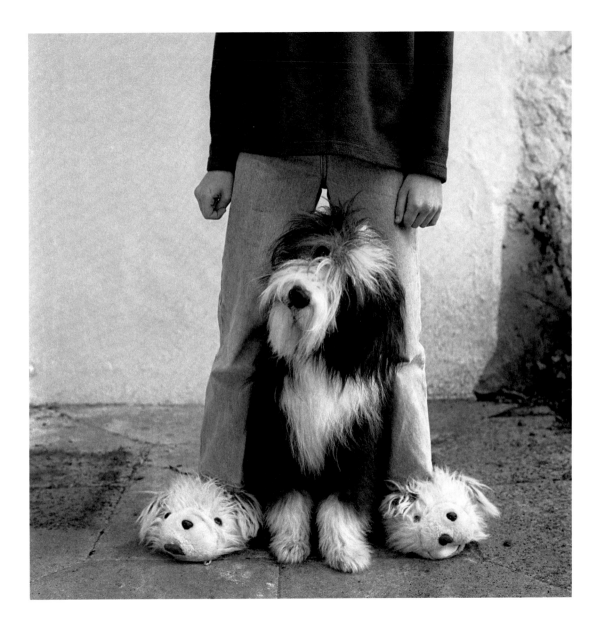

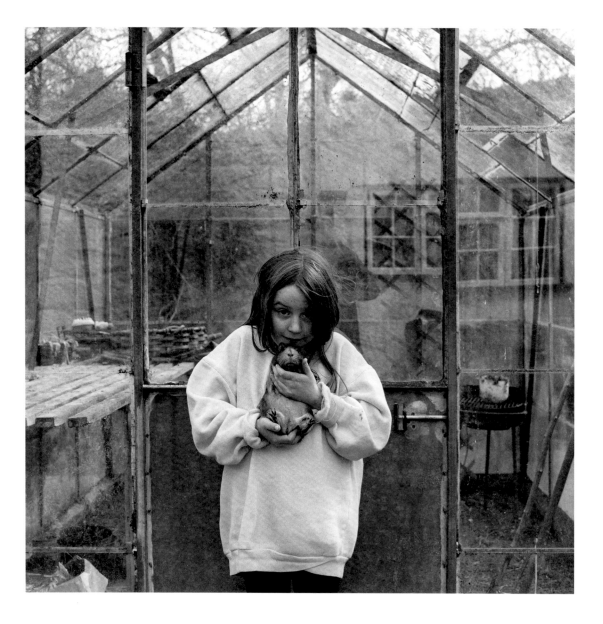

You become responsible forever
for what you have tamed.

Antoine de Saint-Exupery

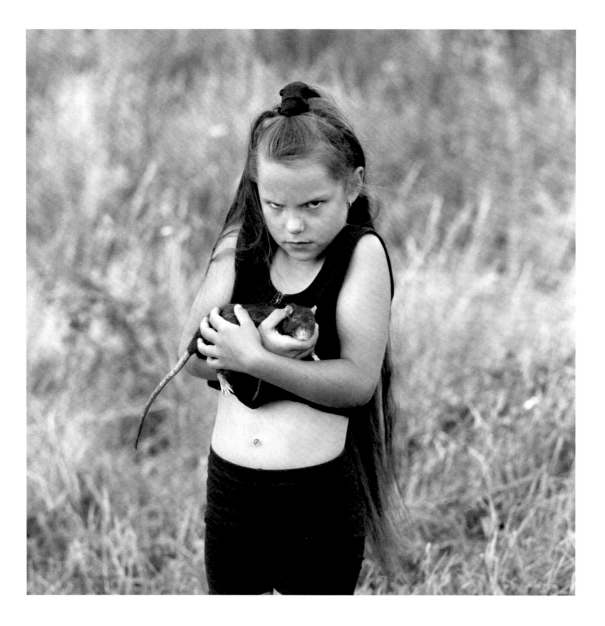

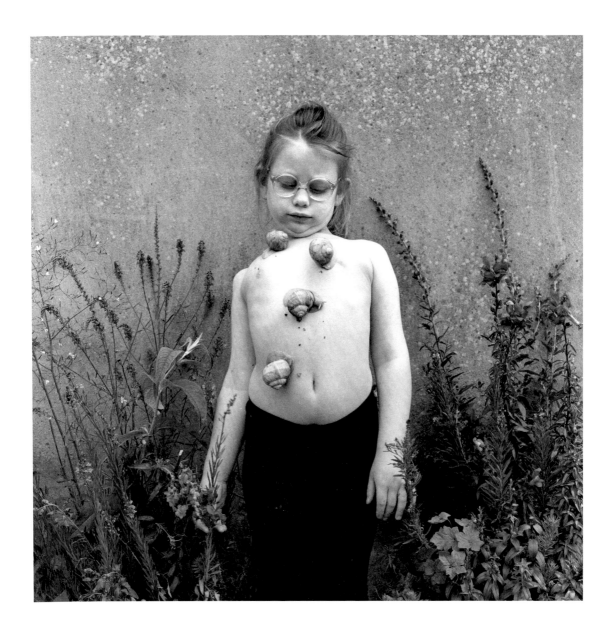

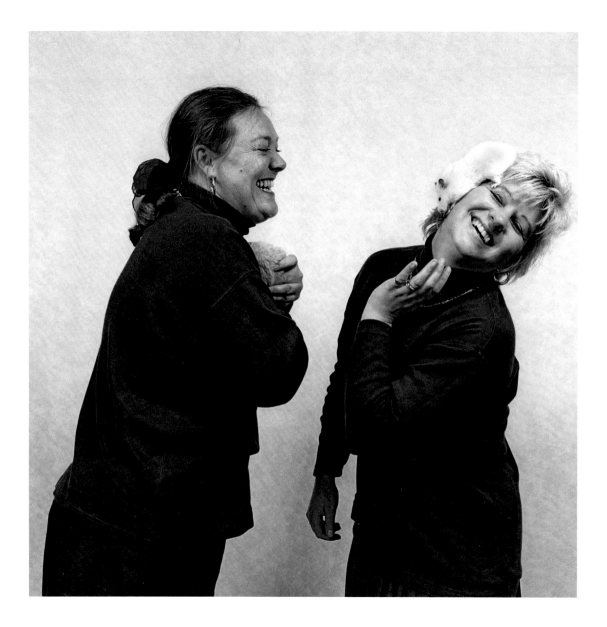

Animals are such agreeable friends –
they ask no questions; they pass no criticisms.

George Eliot

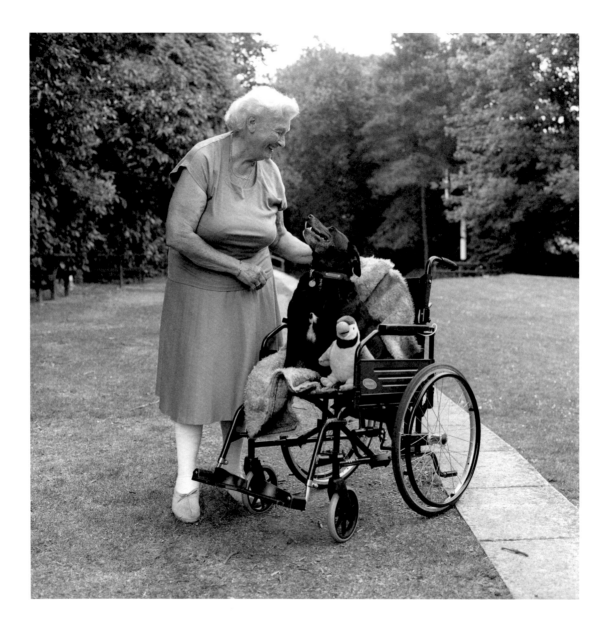

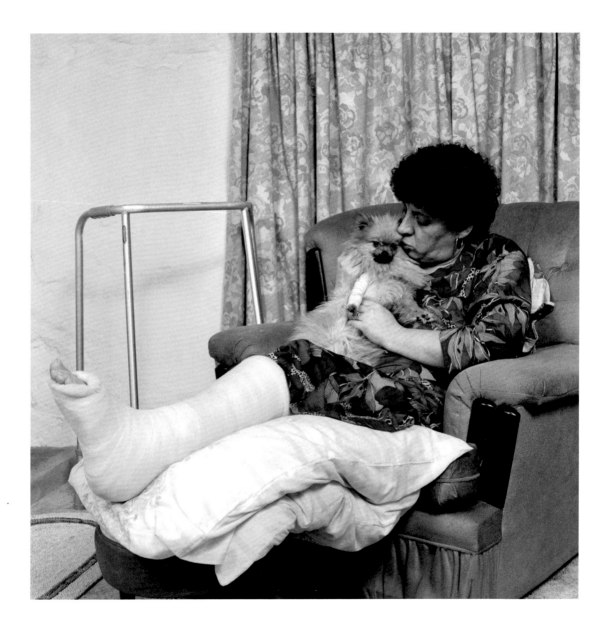

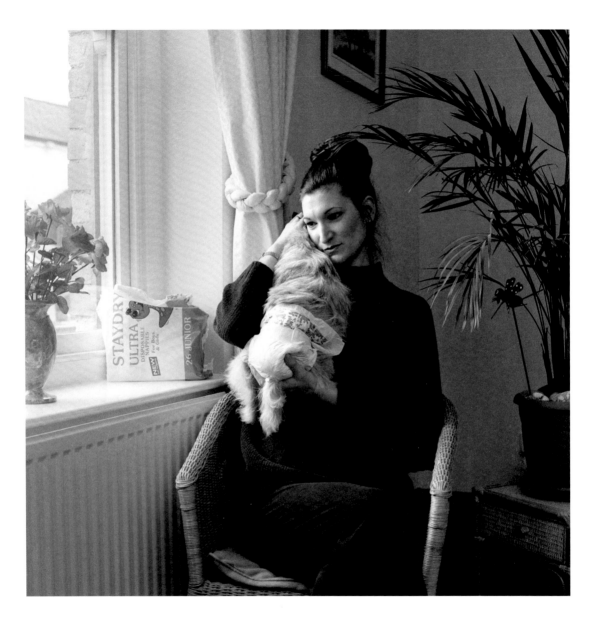

Every dog must have his day.

Jonathan Swift

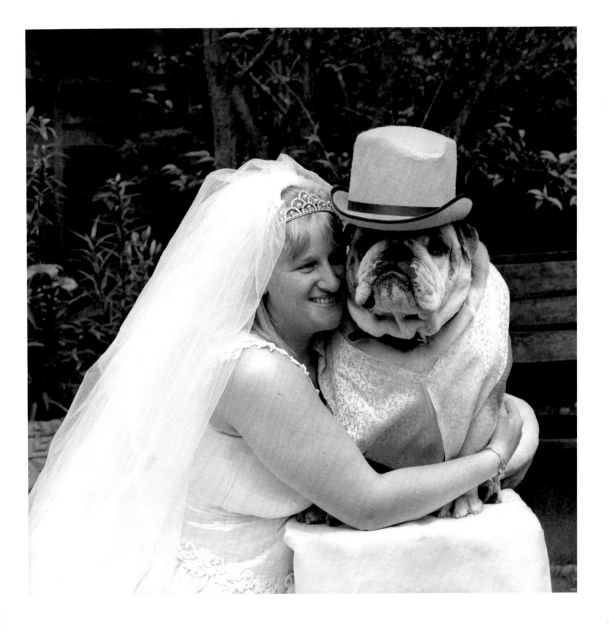

From the oyster to the eagle, from the swine to the tiger, all animals are to be found in men and each of them exists in some man, sometimes several at the time. Animals are nothing but the portrayal of our virtues and vices made manifest to our eyes, the visible reflections of our souls. God displays them to us to give us food for thought.

Victor Hugo